DEBORAH W.
AND FREDERICK DAHLINGER, JR.

Circus Museum
THE JOHN AND MABLE RINGLING MUSEUM OF ART ART SPACES

The John and Mable Ringling Museum of Art, The State Art Museum of Florida, Florida State University in association with Scala Arts Publishers

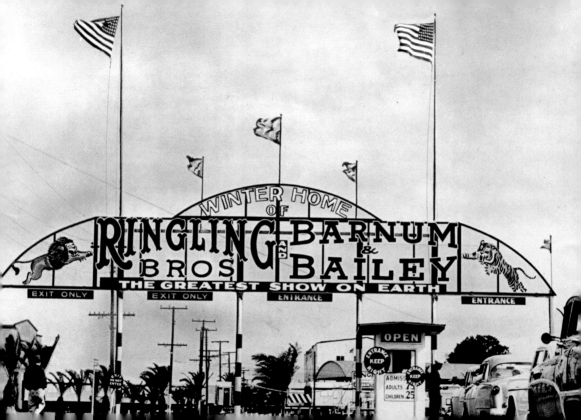

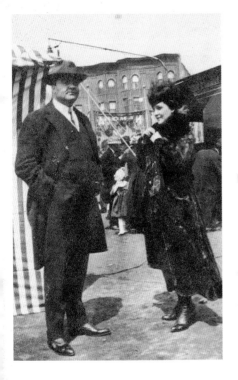

Introduction

In 1927, circus impresario John Ringling (1866–1936) moved the winter quarters of the Ringling Bros. and Barnum & Bailey show from Bridgeport, Connecticut, to Sarasota, Florida. During its time there, winter quarters became a major tourist attraction, drawing hundreds of thousands of visitors. A wonderfully exotic feel settled on the city as performers and workers became part of the local community. Only in Sarasota could one find beaches filled with practicing acrobats, local

← Ringling Bros. and Barnum & Bailey winter quarters, Sarasota, Florida, *c.* 1945

← John and Mable Ringling on the circus lot in Chicago, Illinois, 1919

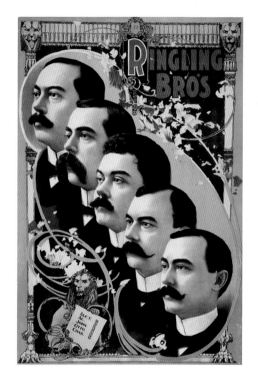

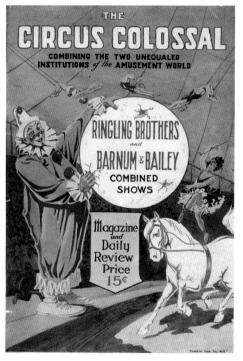

bowling teams competing against talented circus midgets, and the night air filled with the trumpeting of elephants.

The circus of the 1920s was very different than the one begun in 1884 by the five Ringling brothers from Baraboo, Wisconsin: Al, Otto, Alf. T., Charles, and John. Through their hard work, the Ringling show quickly developed from a small wagon operation into a major railroad circus that competed with the world-renowned Barnum & Bailey Circus.

With James A. Bailey's death in 1906, the Barnum & Bailey show was left without strong leadership, and the Ringling brothers purchased *The Greatest Show on Earth* the following year. Originally run as separate units, the two gigantic circuses joined forces in 1919 to form the Ringling Bros. and Barnum & Bailey Combined Shows, *The Greatest Show on Earth*. The circus program boldly proclaimed: "The Circus Colossal Combining the Two Unequaled Institutions of the Amusement World."

← Ringling Bros. poster, 1898

← Ringling Bros. and Barnum & Bailey Combined Shows program, 1919

Circus Museum

To honor the memory of John Ringling, A. Everett "Chick" Austin, Jr., the first director of The John and Mable Ringling Museum of Art, established the Circus Museum in 1948. It was the first museum in the country to document the rich history of the American circus. The original building occupied an area once used to park the Ringlings' Rolls Royces and Pierce-Arrows. Austin added a circular rotunda, the shape of which suggests a circus tent. When the museum opened, the *Sarasota Herald Tribune* reported that it was "decorated with paneling in Louis XV style now painted red and gold. Tall windows of glass brick admit the light; huge mirrors reflect it. Mammoth frames make proscenium arches for low stages." Architectural fragments from one of the Astor residences provide some of the details, giving the museum a sense of drama, which greatly appealed to Austin, who had a passion for theater. A new building, opened in 1966, housed a display of wagons and

→ Circus Museum

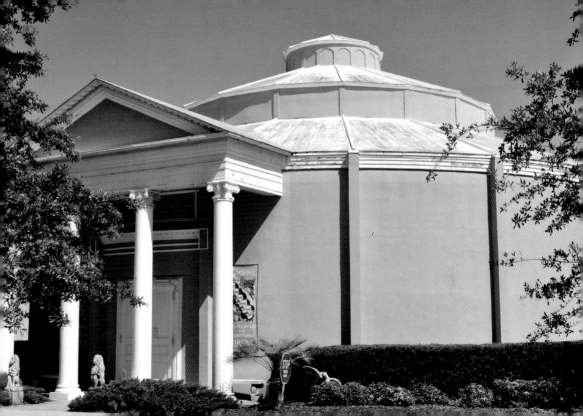

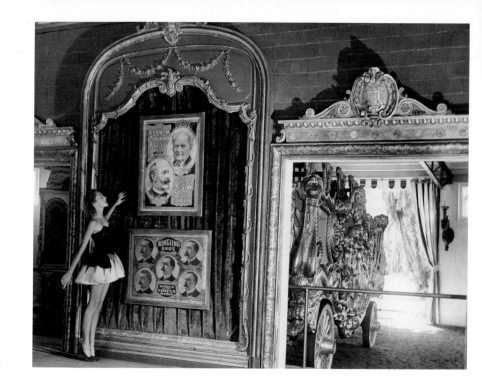

→ Circus Museum, *c.* 1950

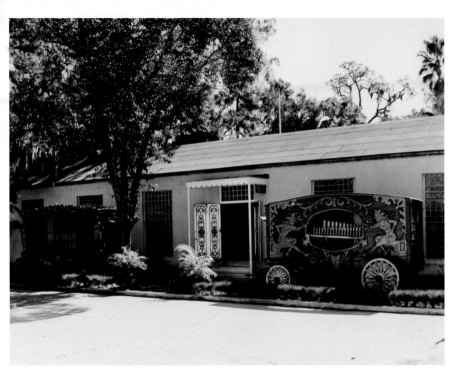

← Circus Museum, *c.* 1960

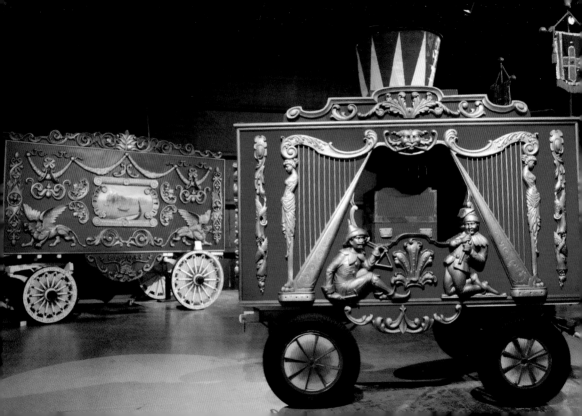

equipment designed to recreate a circus back-yard, the "little-known world, behind the magic and glamour of the big top…where the circus performers lived and performed the hundreds of different jobs necessary in the operation of a circus."

The original circus collection consisted of costumes, props, and posters, donated by local circus families. Following the closure of winter quarters in Sarasota in the late 1950s, the museum received a major influx of artifacts, including costumes, wagons, and equipment left on the lot after the circus moved twenty-five miles south to Venice, Florida. The Florida State Legislature provided funding for additional exhibition and storage space to accommodate the growing collection. The wagon room was opened in 1976.

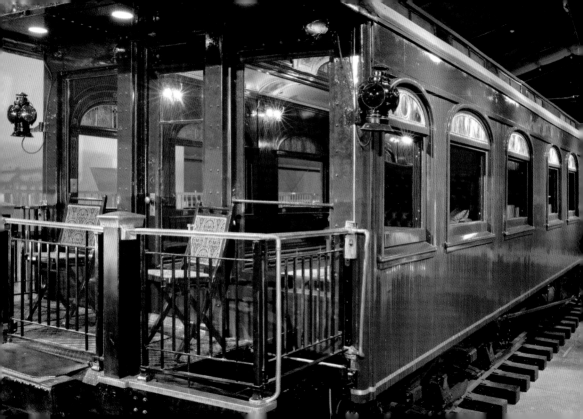

Wisconsin Railcar

One of the highlights of the Circus Museum is the *Wisconsin*, the first private railroad car of John Ringling and his wife Mable Burton Ringling (1875–1929). They used this 65-ton, 79-foot-long wooden car, constructed by the Pullman Company, for both business and pleasure. As with all private cars, it was well appointed with opulent interiors and luxurious finishes.

Having previously established a relationship with the Pullman firm by buying second-hand cars for the circus, John Ringling eventually commissioned a new private car for his own personal use. Ringling placed the order in December 1904 and instructed Pullman to use as much "good old finish, as possible," meaning material on-hand or salvaged from other railroad cars. The final cost of the car was $11,325.23, about half the amount spent on other private cars of the day. The name *Wisconsin* was chosen to honor the home state of both the Ringling brothers and their circus. In

← *Wisconsin* private Pullman railcar, 1905

Following page:
Wisconsin

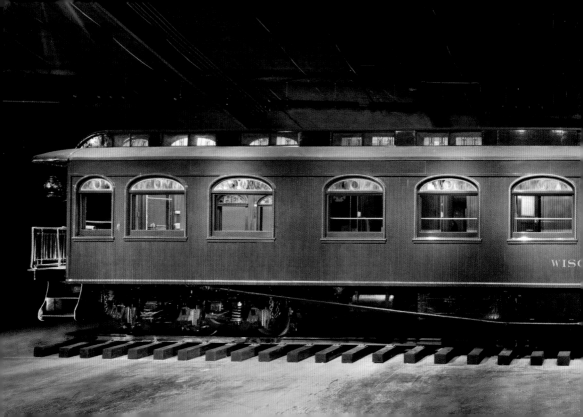

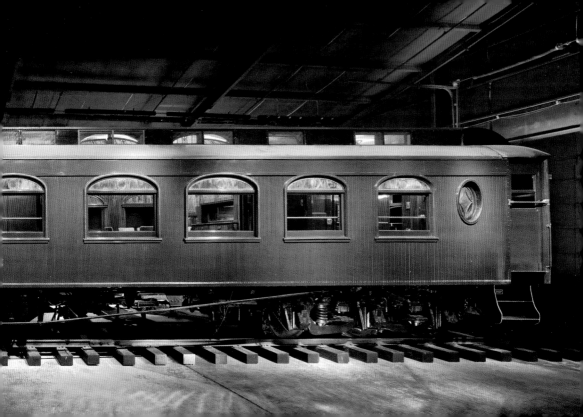

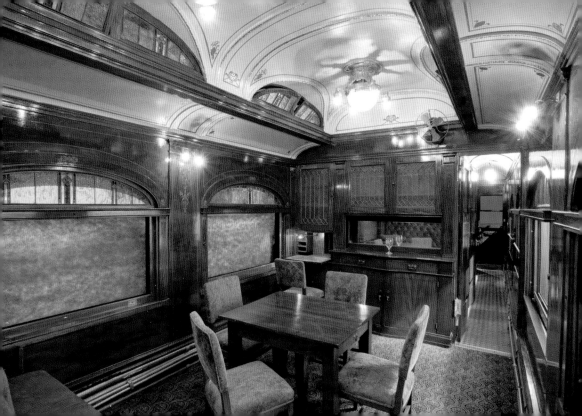

March 1905, Ringling took delivery of the car from Pullman's shop in Calumet, Illinois.

For the next eleven years, John Ringling conducted the business of the shows owned and operated by the Ringling brothers aboard the *Wisconsin*. A number of times during the season the car joined with the circus train. Pleasure trips were taken to Utah and Yellowstone National Park, as well as to Sarasota, where the Ringlings purchased property in 1911. In fact, one of the last trips the Ringlings took in the car was to Sarasota in early 1916.

Much of what is known about life on the *Wisconsin* is drawn from *Born to Be*, an autobiography by Taylor Gordon, who was hired by John Ringling in 1910 as a driver for one of his holdings, the Montana Smith River Development Company. Gordon later became the Ringlings' chauffeur, porter, cook, waiter, and valet, and would travel with them around the country. Gifted with a beautiful voice, Gordon left the Ringlings' employment to pursue a singing career, performing at Carnegie Hall in 1927 and touring England and France for two years. His account of the Ringlings includes references to John's love of German Pilsner beer and Mable's preference for early breakfasts.

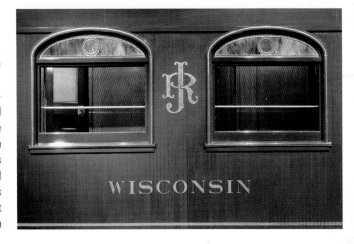

← *Wisconsin*, dining room

↑ *Wisconsin*, detail of name

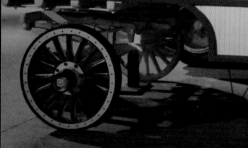

RINGLING BROS. *and* BARNUM & BAILEY

Ringling Bros. and Barnum & Bailey Ticket Wagon #122

The Circus Museum is home to a number of historic circus wagons, each designed to serve one or more specific functions. Large circuses would have had more than a hundred of these wagons, which were transported around the country by train from 1872 onward.

Built in 1911, Ringling Bros. Ticket Wagon #122 doubled as the office from which as many as 1,200 people were directed to accomplish the daily tasks necessary to stage the circus. On a typical day, more than 10,000 tickets for a single performance were sold through the wagon's multiple windows.

← Ringling Bros. and Barnum & Bailey Ticket Wagon #122, 1911

Tibbals Learning Center

The newest chapter in the history of the Circus Museum began with the opening of the Tibbals Learning Center in 2006. This spacious facility houses an orientation theater, a display of circus posters, and the incredible *Howard Bros. Circus Model*, the world's largest miniature circus. It also includes a timeline of circus history, from antiquity to today, interspersed with objects relating to famous figures such as the great showman P. T. Barnum, the diminutive Tom Thumb, and the legendary "Buffalo Bill" Cody. Behind the scenes are state-of-the-art archives, containing Ringling papers, museum records, and circus documents, such as posters, photographs, costume designs, and souvenir programs. An addition, opened in 2012, features a series of

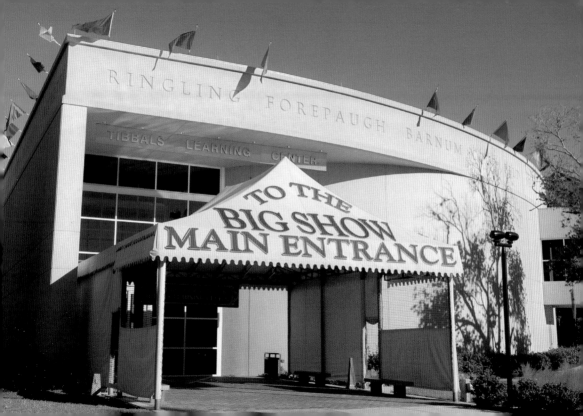

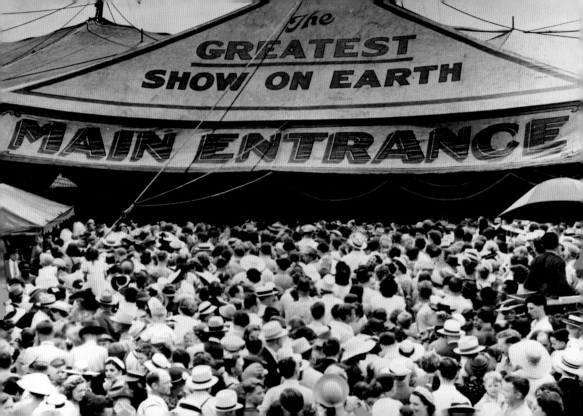

displays on celebrated circus performers, past and present, and a number of hands-on interactives that allow visitors of all ages to become center ring stars.

Welcoming visitors to the Tibbals Learning Center is an entrance tent similar to one used by the Ringling Bros. and Barnum & Bailey Combined Shows in the early twentieth century.

← Circus marquee, *c.* 1940

← Tibbals Learning Center, flagpoles

Following page:
Barnum & Bailey big top, *c.* 1906

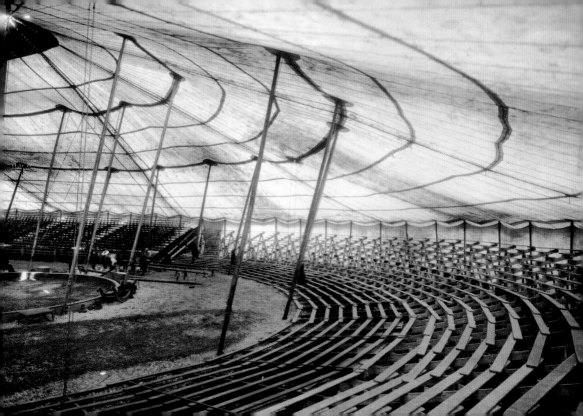

→ Tibbals Learning Center,
 wagon display

Following spread:
Tibbals Learning Center,
interactive gallery

Lining the exterior walls is a frieze where names such as Barnum, Bailey, and Ringling are joined with those of other individuals who played equally important roles in circus history. From John Bill Ricketts, the father of the American circus, to the Feld family, the current owners of Ringling Bros. and Barnum & Bailey, these names represent some of the greatest contributors to the country's most popular form of live entertainment.

Lining the walkway beside the Tibbals Learning Center are six towering flagpoles that represent the center poles of the big tops used by the Ringling Bros. and Barnum & Bailey Combined Shows in the early twentieth century. These poles supported a canvas structure covering 85,000 square feet that could easily accommodate more than 12,000 people at a single performance. Alternating with the poles were performance areas, including three 42-foot rings and four 32-foot stages.

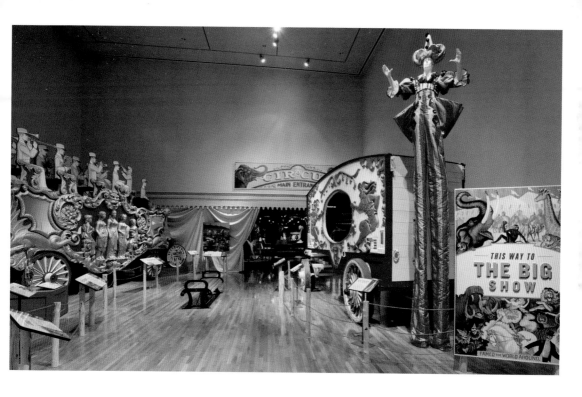

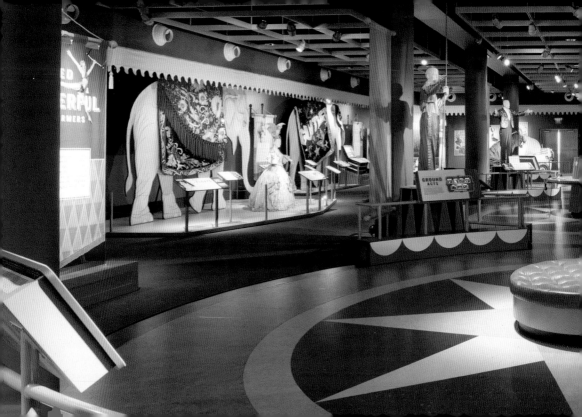

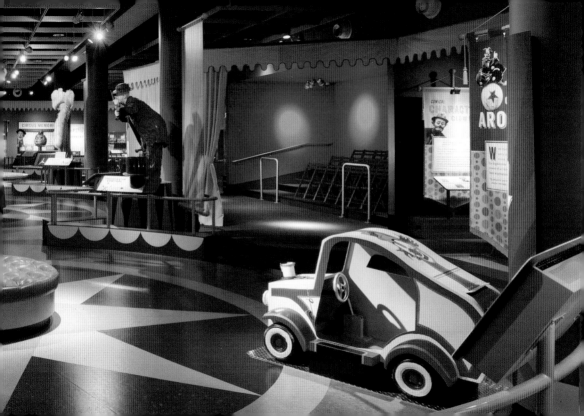

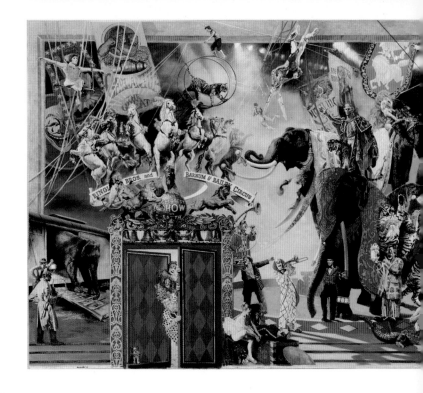

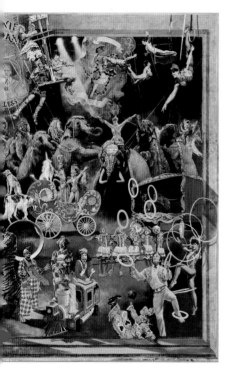

The Greatest Show on Earth

In the entrance hall of the Tibbals Learning Center is *The Greatest Show on Earth*, a giant mural that matches the splendor and grandeur of the Ringling show. Covering more than 924 square feet, this colossal work was donated to the Ringling Museum in 2012 by the Feld family and Feld Entertainment, Inc., the parent company of Ringling Bros. and Barnum & Bailey.

In 1989, Kenneth Feld, Chairman and CEO of Feld Entertainment, commissioned William Woodward, a distinguished American artist, to create a mural for the lobby of his corporate headquarters in Virginia. The mural, which took two years to complete, captures the excitement and magic of the circus while also documenting the Ringling show of the 1970s and 1980s. A cavalcade of

← *The Greatest Show on Earth*, a mural by William Woodward, 1990

comic clowns, high-flying aerialists, wonderful wire-walkers, ponderous pachyderms, dancing tigers, and prancing horses burst forth from the canvas with a spontaneity that is both exhilarating and timeless. A closer look reveals the great aerialist Dolly Jacobs, master clowns Lou Jacobs and Frosty Little, and the incredible animal presenter Gunther Gebel-Williams.

For twenty-two years, Woodward's work infused the lobby of the Feld headquarters with the splendor of the Ringling show. Now in its permanent home, it continues to evoke the magic, drama, and excitement of the circus.

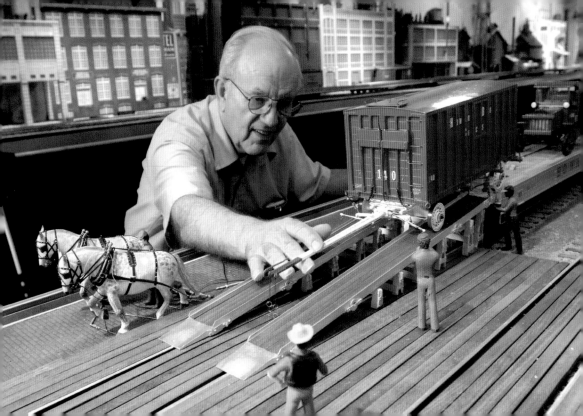

Howard Bros. Circus Model

At the heart of the Tibbals Learning Center is the *Howard Bros. Circus Model*, the largest miniature circus in the world, which acts as an ongoing testimony to the rich history of the American circus. The model is a ¾-inch scale, more than 44,000-piece replica of the 1919–38 Ringling Bros. and Barnum & Bailey Combined Shows. It is the life's work of circus historian and model builder Howard C. Tibbals, who began constructing it in 1956. To ensure the model's accuracy, Tibbals used historic photographs and other documentation as well as his own meticulous measurements of original wagons. Focusing on one area at a time, he took more than eighteen years to complete the big top.

← Howard C. Tibbals

→ *Howard Bros. Circus Model*

Having been a feature exhibit at the 1982 World's Fair in Knoxville, Tennessee, the model was showcased at both the Henry Ford Museum in Dearborn, Michigan, and the Circus World Museum in Baraboo, Wisconsin, before making its permanent home at the Ringling—the only place where it has ever been seen in its entirety.

Just like the real circus, the model came packed on a train, with each of the 152 wagons placed carefully on one of fifty-seven flatcars.

Before its arrival, 996 linear feet of rail were hand-laid, with every spike driven individually. The wagons that carried the cookhouse tent and equipment were unloaded first, followed by the baggage wagons that carried all of the basic components of the model. The 7,000 folding chairs, the poles for all the tents, and the contents of the souvenir stands on the midway were similarly placed with historical accuracy.

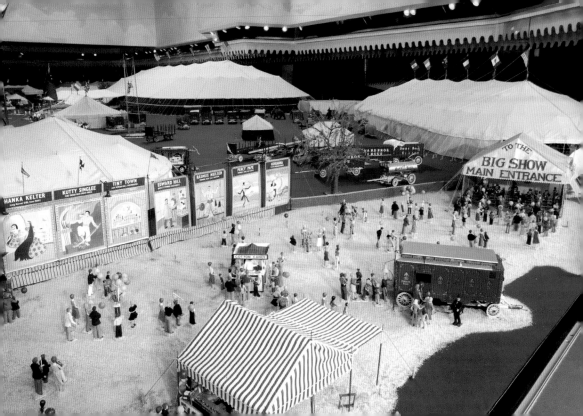

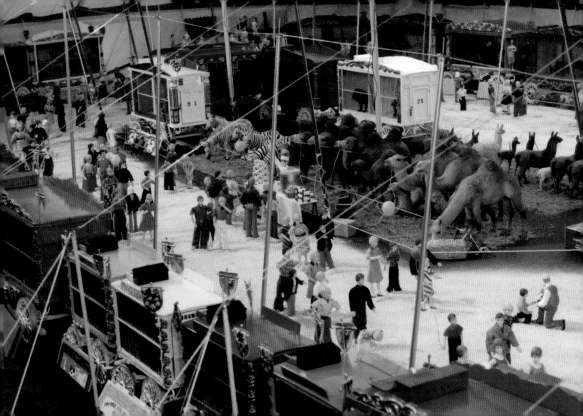

The backyard of the circus was where the day-to-day life of performers and workers took place. In fact, circuses of the early twentieth century were called "canvas cities," as they had all of the amenities the showfolks needed. The commissary wagon, for instance, was stocked with toiletries, magazines, and clothing, and a barber's tent provided haircuts—all of which have been faithfully recreated here. The model also includes a dining tent in which the showfolks are served on more than 900 individual place settings, complete with tiny silverware. In addition, the model recreates the dressing tent, which was located behind the big top. Performers can be seen trying on costumes, fixing their hair, and applying their makeup with their individually labeled trunks and water buckets beside them.

Traveling circuses brought amazing and sometimes never-before-seen sights to cities and towns across America. This experience is recreated in

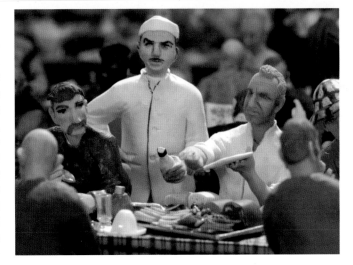

← *Howard Bros. Circus Model*, menagerie

↑ *Howard Bros. Circus Model*, dining tent

→ *Howard Bros. Circus Model,*
 sideshow

the model, which includes a sideshow and menagerie. Inside the latter are miniature animals that are just as fascinating and beautiful as the real animals presented by the historic circus. Throughout the tent, elaborate caged wagons are filled with exotic beasts that were unfamiliar to the average American. Each of the wagons featured here replicates one formerly used by the Ringling show.

The big top and all of its components were the first pieces of the model to be created. With almost a hundred artists performing simultaneously in twenty-one different acts, spread out over four stages and three rings, the performance displayed here is unlike an actual one under the big top, where only a few acts would be seen at any one time. These acts would be similar in nature so that patrons at one end of the tent saw the same show as those at the opposite end. In the model, the famous clown Lou Jacobs can be seen stepping out of his miniature car on the front track and the "Great Wallendas" are shown walking the wire above.

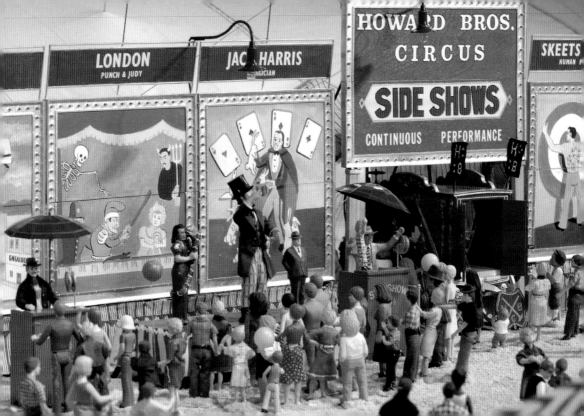

Dunn Bros. Circus Model

→ Harold Dunn

Following spread:
Dunn Bros. Circus Model,
Egypt wagon

On the second floor of the Tibbals Learning Center is a 148-foot-long display case housing a parade of miniature people, animals, and vehicles created by circus enthusiast and model builder Harold Dunn. Most of the exhibit features models of parade wagons used on many different circuses. The rest consists of handcrafted floats from the Ringling Bros. and Barnum & Bailey Combined Shows, designed by Norman Bel Geddes and Miles White from 1941 to 1956. Best known for their whimsical ideas, cutting-edge designs, and striking color palettes, Bel Geddes and White stretched human imagination and forever changed the look of the American circus.

Street parades marked the arrival of the circus into town. By providing a free glimpse into the world of the exotic, they enticed people to buy tickets to the show. Spectacles, or "specs," were parades that took place around the hippodrome track inside the big top and featured as many of the circus performers and animals as the director was able to include. With their own elaborate costumes and unique musical scores, specs brought to life historic events, imaginative themes, and tales of distant lands. They also gave spectators a hint of the excitement to follow.

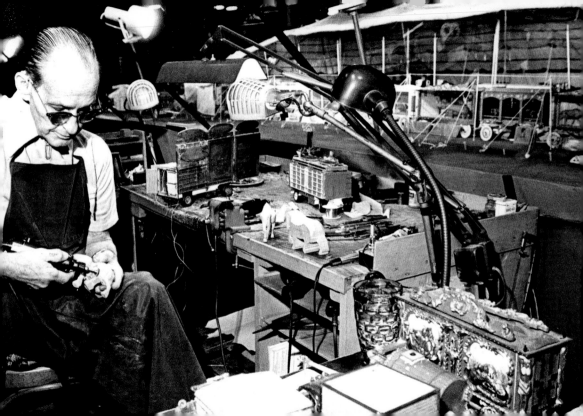

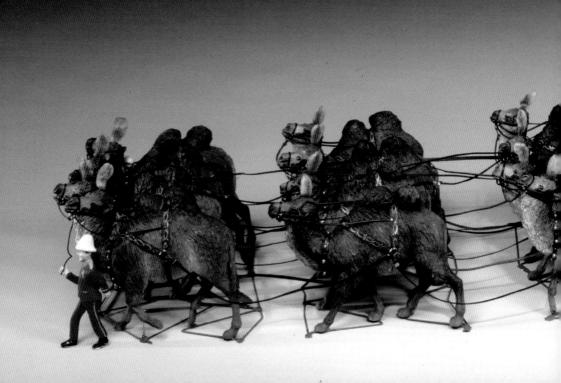

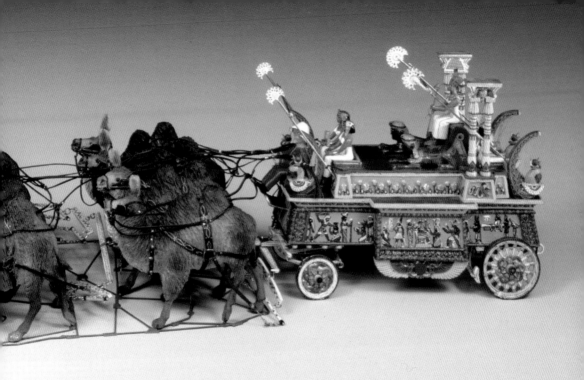

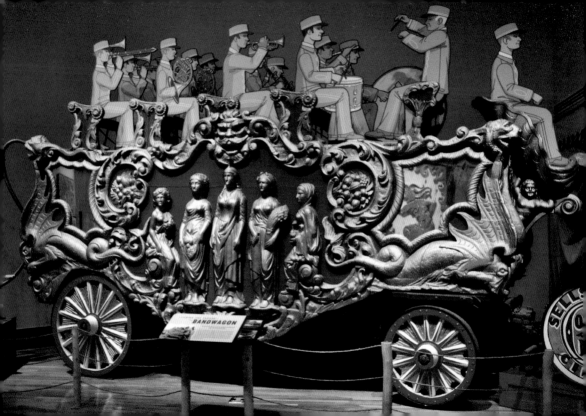

Five Graces Bandwagon

The Five Graces, as it was known on the circus lot, originated as the giant Gem Bossed Car of Freedom in 1878 and was converted into a bandwagon by 1890. It is one of the oldest American circus parade wagons in existence.

Bandwagons such as the Five Graces formed part of the street parades that announced the arrival of the circus. They carried bands of professional musicians and were decorated with a variety of motifs derived from mythology and executed in the Rococo style. Ornate scrollwork, imposing tableaus, and gilded figures were among the most popular decorations of the 1870s and 1880s. The figures on the Five Graces represent Columbia and the four seasons.

← Five Graces Bandwagon, 1878

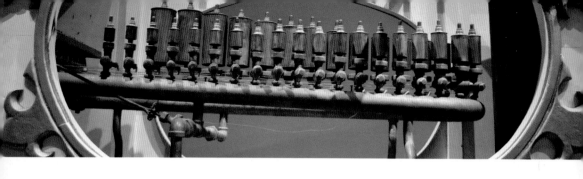

Two Jesters Calliope Wagon

The last wagon in the street parade was a steam calliope, which played music that drew people to the lot. Made by the Sells-Floto Circus in about 1920, the Two Jesters Calliope Wagon was one of the last constructed.

Housed in wagons decorated with woodcarvings, calliopes were steam-powered instruments consisting of between twenty and thirty-seven tuned brass whistles that were activated by special valves controlled by a regular piano-style keyboard. The non-chromatic nature of these instruments, coupled with the high forces necessary to depress the keys made playing them a very difficult assignment. Under the right conditions, sound from the whistles could be heard for ten miles, reminding everyone that the circus was in town. With space for thirty-six whistles, the instrument inside the Two Jesters is the largest in existence.

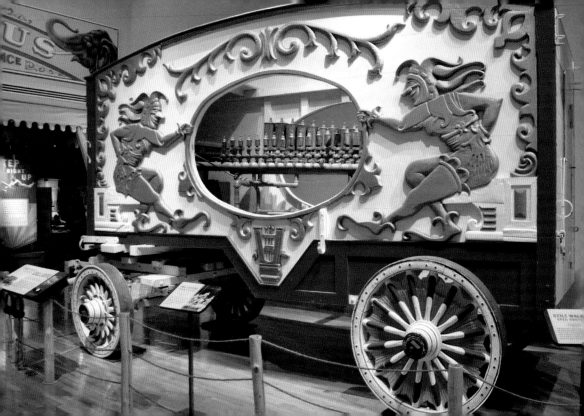

Lou Jacobs's Miniature Clown Car

One of the most popular exhibits in the Tibbals Learning Center is a replica of a miniature clown car that visitors can try out for themselves. The replica is based on an actual car displayed nearby that was used by Lou Jacobs, who joined Ringling Bros. and Barnum & Bailey's clown alley in 1925. Jacobs went on to become a worldwide circus celebrity, who was easily identified by his distinctive costume, which included a tiny hat and oversized shoes.

After years of work, Jacobs perfected a miniature clown car gag that became one of his best-known comedic acts. A talented contortionist, he would fold his six-foot-tall body into a tiny working car with an engine, horn, and water pump. Once in, he would race the car around the hippodrome track and finally stop at a gas station where all sorts of comic mishaps would take place, to the audience's delight.

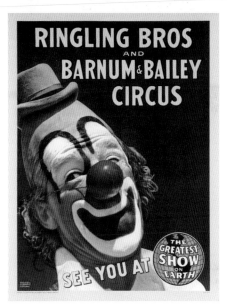

← Lou Jacobs's miniature clown car, c. 1951

← Lou Jacobs, c. 1944

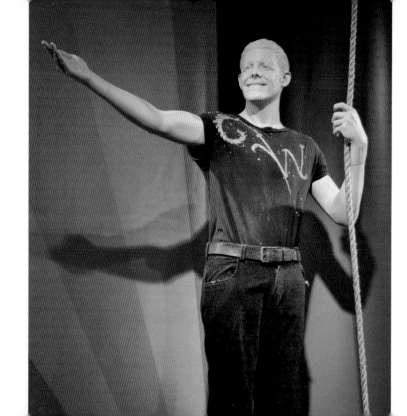

Nik Wallenda's Costume

Among the many costumes in the circus collection is one belonging to Nik Wallenda, perhaps today's best-known circus performer. A member of the world-famous, seven-generation Wallenda family, he is renowned for his athletic skill, daring, and fearlessness on the high wire. He first performed at the age of two and was walking the wire by the age of four. He started performing professionally nine years later.

In 2008, while wearing this outfit, he set a Guinness World Record for the longest distance and greatest height ever traveled by bicycle on a high wire. He has since performed incredible feats of strength and daring, crossing Niagara Falls in 2012 and the Grand Canyon in 2013 as part of his Walk Across America tour.

← Nik Wallenda's costume, *c.* 2008

The Circus Today

→ Tibbals Learning Center, contemporary gallery

Now entering its third century as one of America's best-loved forms of entertainment, the circus continues to evolve. Contemporary shows range from the theatrical Cirque du Soleil to the intimate Circus Sarasota and Big Apple Circus in New York. Ringling Bros. and Barnum & Bailey have multiple units touring the country with productions that include the latest in audio and video technologies. While their differences are pronounced, today's circuses are founded on the same basic principles as those more than 200 years ago: the amazing capacity of the human body and the remarkable daring of the human spirit.

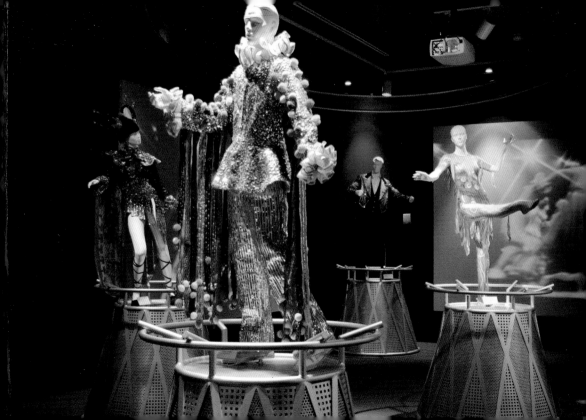

This edition © 2014 Scala Arts
Publishers, Inc.

First published in 2014 by
Scala Arts Publishers, Inc.
141 Wooster Street, Suite 4D
New York, NY 10012
www.scalapublishers.com

Scala Arts & Heritage
Publishers Ltd.
21 Queen Anne's Gate
London SW1H 9BU
United Kingdom

in association with
The John and Mable Ringling
Museum of Art

ISBN: 978-1-85759-892-6

Edited by Stephanie Emerson
Designed by Inglis Design
Produced by Scala Arts
Publishers, Inc.

Printed and bound in China
10 9 8 7 6 5 4 3 2 1

Front cover: Tibbals Learning
Center, interactive gallery
Back cover: Circus Museum,
c. 1950

All images are courtesy The John
and Mable Ringling Museum of Art.